I am a divine daughter of God.

My name is

[]

ISBN 13: 978-1-4621-4465-5

Published by CFI, an imprint of Cedar Fort, Inc.
2373 W. 700 S., Suite 100, Springville, UT 84663
Distributed by Cedar Fort, Inc., www.cedarfort.com

Cover and interior layout by Shawnda T. Craig
Cover design © 2023 Cedar Fort, Inc.

Printed in India

10 9 8 7 6 5 4 3 2 1

Printed on acid-free paper

DEAR DIVINE DAUGHTER

DIVINE &
HERE TO
SHINE
Journal

BECOMING CHRISTLIKE
WITH BIBLE *Women*

AMBER CORKIN & AUBRI ROBINSON

CFI • AN IMPRINT OF CEDAR FORT, INC. • SPRINGVILLE, UTAH

contents

A NOTE FROM THE
authors

Our book, *Dear Divine Daughter: Inspiring Stories of Bible Women,* tells thirty-four stories of women with a wide variety of backgrounds and life situations. There is a young maid and an old prophetess, a beautiful queen and a Hebrew slave, an influential business woman and a poor widow. All of the women and girls are unique, but they all share a divine identity as daughters of God and possess inspiring Christlike characteristics.

We assigned each Bible woman a specific characteristic she strongly exemplifies. Anna is holy, Esther is brave, Martha is caring, the Shunnammite Woman is problem-solving, and the Widow of Zarephath is faithful, to name a few. We know that just like these inspiring Bible women, you are a divine daughter of God with incredible, unique strengths! The more you work on sharing those strengths and developing other divine characteristics, the more you are living up to your divine potential.

With space for you to write your thoughts, this journal dives deeper into the prompts found at the end of each Bible woman's story. You will also find thought-provoking questions, engaging challenges, inspiring quotes, and more.

We know that by working through this journal and becoming more like the inspiring Bible women, you will SHINE BRIGHTER and be an inspiring example to others! Work as quickly or as slowly as you like. Jump around or work through it sequentially. You get to decide how to make the most of this journal. All you need to get started is a copy of *Dear Divine Daughter: Inspiring Stories of Bible Women,* a pen, and the understanding that you are divine and here to shine!

xoxo,
Amber Corkin & Aubri Robinson

ABOUT ME
I am unique!

Fill in each box with information about you.

My age:

My favorite color:

My favorite food:

My favorite holiday:

My favorite animal:

My favorite song:

I do not like:

I like to:

I want to:

CHARACTERISTICS
that describe me

- ☐ peacemaking
- ☐ holy
- ☐ just
- ☐ trusting
- ☐ hopeful
- ☐ brave
- ☐ obedient
- ☐ honorable
- ☐ learned
- ☐ pioneering
- ☐ dependable
- ☐ creative
- ☐ virtuous
- ☐ influential
- ☐ caring
- ☐ devoted
- ☐ receptive
- ☐ humble

- ☐ selfless
- ☐ confident
- ☐ long-suffering
- ☐ generous
- ☐ god-fearing
- ☐ action-oriented
- ☐ inspired
- ☐ repentant
- ☐ persistent
- ☐ loyal
- ☐ missionary-minded
- ☐ problem-solving
- ☐ charitable
- ☐ faithful
- ☐ independent
- ☐ determined
- ☐ other:

CHARACTERISTICS
to work on

- ☐ peacemaking
- ☐ holy
- ☐ just
- ☐ trusting
- ☐ hopeful
- ☐ brave
- ☐ obedient
- ☐ honorable
- ☐ learned
- ☐ pioneering
- ☐ dependable
- ☐ creative
- ☐ virtuous
- ☐ influential
- ☐ caring
- ☐ devoted
- ☐ receptive
- ☐ humble

- ☐ selfless
- ☐ confident
- ☐ long-suffering
- ☐ generous
- ☐ god-fearing
- ☐ action-oriented
- ☐ inspired
- ☐ repentant
- ☐ persistent
- ☐ loyal
- ☐ missionary-minded
- ☐ problem-solving
- ☐ charitable
- ☐ faithful
- ☐ independent
- ☐ determined
- ☐ other:

4

CHRISTLIKE
characteristics

Bible women are amazing examples, but there are likely people in your own life whom you can look up to and learn from. Who in your life comes to mind when you think of each Christlike characteristic? I can be . . .

peacemaking like

holy like

just like

trusting like

hopeful like

brave like

obedient like

honorable like

learned like

pioneering like

dependable like

creative like

virtuous like

influential like

caring like

devoted like

receptive like

humble like

selfless like

confident like

long-suffering like

generous like

god-fearing like

action-oriented like

inspired like

repentant like

persistent like

loyal like

missionary-minded like

problem-solving like

charitable like

faithful like

independent like

determined like

PEACEMAKING
Abigail

Abigail was a peacemaker and softened the heart of an angry man who was seeking revenge. Her heartfelt plea and generous actions saved her household.

1 Samuel 25:2–42

Dear divine daughter, how can you be a peacemaker?

See page 2 in *Dear Divine Daughter: Inspiring Stories of Bible Women.*

Reach Higher

How does a peacemaker interact with others? Which situations in your life tend to make you or others upset, and what specific things can you do to bring peace? How can you find inner peace despite what is happening around you?

Shine Brighter

Who do you have a conflict with? Try to see things from their perspective. Write them a peacemaking letter, and then write about your experience. (Ideas of things you could put in your letter: you can apologize, you can tell them things you admire about them, and you can suggest ways to resolve your conflict.)

MAY THE GOD OF HOPE FILL *you* WITH JOY & PEACE

ROMANS 15.13

HOLY
Anna

Anna became holy as she devoted herself to God. She fasted, prayed, and always stayed close to the temple. Anna's holy and consecrated life allowed her to meet the Savior and testify of Him.

Luke 2:36–38

Dear divine daughter, how can you be more holy?

See page 5 in *Dear Divine Daughter: Inspiring Stories of Bible Women*.

Reach Higher

What are places you have visited that feel sacred and holy? How can you make your home or bedroom a holier place?

Shine Brighter

For thirty minutes, completely dedicate your time to God. What did you choose to do and why? How did it make you feel?

Draw the place that feels most holy to you.

JUST
Deborah

Deborah was a righteous judge over Israel and played an important role in freeing her people from slavery. Being just and fair made Deborah a better leader.

Judges 4, Judges 5:1-15

Dear divine daughter, how can you be more just?

See page 6 in *Dear Divine Daughter: Inspiring Stories of Bible Women*

Reach Higher

Being *just* means acting according to what is morally right and fair. Being *merciful* means showing compassion and forgiveness towards someone. God beautifully balances being just and merciful. Why do you think both characteristics are important?

Shine Brighter

Read these just behaviors and circle the one you want to work on the most. Try it out for a day and record your experience.

Accept the consequences of a mistake you have made.

Share with others and take turns.

Listen more than talk during a conversation.

Include people in an activity, being careful not to leave anyone out.

Follow the rules during a sporting event or other game.

Respect others—even people who are different from you.

Treat people equally and do not play favorites.

Try to see the other person's perspective during a disagreement.

Be honest on tests or other work.

Love everyone.

Let ALL you DO be DONE in LOVE

TRUSTING
The Debtor Widow

The Debtor Widow trusted the prophet, following his counsel even when others would have doubted. Her trust in the prophet and God helped her overcome a stressful situation and brought blessings to her family.

2 Kings 4:1-7

Dear divine daughter, how can you put your trust in God?

See page 9 in *Dear Divine Daughter: Inspiring Stories of Bible Women.*

Reach Higher

When was a time you decided to trust in God or a prophet even if it was hard? How do you think God feels about the choice you made? Write down any other thoughts and feelings you have.

Shine Brighter

Interview a friend or family member about a time when they put their trust in God. Come up with five questions you can ask them, record their answers, and write about what you learned from the experience.

Who I interviewed:

Q:
A:

Q:
A:

Q:
A:

Q:
A:

Q:
A:

What I learned:

TRUST in the LORD with all thine *heart,* and lean not unto thine OWN UNDERSTANDING. *In all thy ways* ACKNOWLEDGE HIM and He shall *direct* THY PATHS.

—Proverbs 3:5–6

HOPEFUL
Elisabeth

Even when Elisabeth was too old to have any children, she remained hopeful and waited on the Lord. Miraculously, at a very old age she became pregnant like she had hoped.

Luke 1:5–80; Luke 7:28

Dear divine daughter, how can you be more hopeful?

See page 10 in *Dear Divine Daughter: Inspiring Stories of Bible Women.*

Reach Higher

Is there something in your life that you are waiting on the Lord for? How has this experience challenged you, and how can you remain hopeful that everything will work out for the best?

Shine Brighter

What do you hope your life looks like later on? Draw and label some of your hopes and dreams for the future. What can you do now to help make your dreams come true?

Think about why a rainbow can be a symbol of hope.
Draw your own rainbow.

BRAVE
Esther

Esther was brave when she said, "If I perish, [then] I perish," and risked her own life to save her people. Because of her bravery, the lives of all the Jews in the kingdom were spared.

Esther 2–4; Esther 5:1–8; Esther 7; Esther 8:1–8; Esther 9:26–32

Dear divine daughter, how can you be brave?

See page 13 in *Dear Divine Daughter: Inspiring Stories of Bible Women.*

Reach Higher

When was a time you did something uncomfortable or scary because you knew it was the right thing to do? How do you feel about that experience now?

Shine Brighter

Think of something you have been wanting to do but have been too scared to try. Face your fear with bravery and do it! Write about your experience.

BE NOT

afraid

ONLY

believe.

—Mark 5:36

OBEDIENT
Hagar

On multiple occasions Hagar was obedient when she listened to God's instructions and followed His counsel. She obeyed God even when it was hard for her. In the end, her obedience produced blessings.

Genesis 16; Genesis 17:20; Genesis 21:9–21; Genesis 25:12–18

Dear divine daughter, how can you be more obedient to God?

See page 14 in *Dear Divine Daughter: Inspiring Stories of Bible Women.*

Reach Higher

When did you choose to be obedient and it led to immediate blessings? When did you choose to be obedient and it did not lead to an immediate reward? Why do you think God asks us to obey Him?

Shine Brighter

Choose something God has asked you to do and commit to be more obedient to Him. Try it and write about the experience.

Write down commandments and the blessings
you receive from obeying them.

commandments	blessings

HONORABLE
Hannah

Hannah vowed that if God would give her a son, then she would dedicate her son's life to Him. After giving birth to a boy, Hannah kept her promise and honorably took her son to the prophet at the temple.

1 Samuel 1; 1 Samuel 2:1–11, 18–21

Dear divine daughter, how can you be honorable and keep your promises?

See page 17 in *Dear Divine Daughter: Inspiring Stories of Bible Women.*

Reach Higher

What is the most important promise you have ever made? Why is it good to keep promises?

Shine Brighter

An honorable person believes in truth, chooses the right, and is reliable and honest. Study the life of a person from history who was known for being honorable. What consequences—good and bad—did they experience for choosing to do what was right? How did their honorable actions impact others? In what ways can you be more like them?

— WITH —
GOD
ALL THINGS ARE
possible

LEARNED
Huldah

Huldah studied and learned to read at a time when most people, especially women, did not. She was a respected prophetess and used her knowledge to help the king interpret God's law.

2 Kings 22; 2 Kings 23:1–3

Dear divine daughter, how can you be more learned?

See page 18 in *Dear Divine Daughter: Inspiring Stories of Bible Women.*

Reach Higher

What is something you want to learn? How can you use that knowledge to bless others?

Shine Brighter

Think about a career you are interested in. Interview a professional in that field and ask them the following questions: Why did you choose your job? How did you get started? What do you like about your job? What do you not like about your job? Write what you learned during the interview.

Learn how to say "hello" in 10 different languages.
Match each word with the correct language.

___ French ___ Portuguese

___ Mandarin Chinese ___ Korean

___ Spanish ___ Arabic

___ Russian ___ Hindi

___ Japanese ___ Italian

1. 你好 / nǐ hǎo

2. こんにち / kon'nichiwa

3. привет / privet

4. ciao

5. أهلًا / 'ahlan

6. olá

7. 안녕하세요 / annyeonghaseyo

8. hola

9. bonjour

10. नमस्ते / namaste

hello!

42

PIONEERING
Jehosheba

Jehosheba was pioneering when she chose to be righteous instead of following in the footsteps of her wicked family. She set a good example for her little nephew and brought peace to the land.

2 Kings 11; 2 Chronicles 22:10–12

Dear divine daughter, how can you be pioneering and choose to be different in good ways?

See page 21 in *Dear Divine Daughter: Inspiring Stories of Bible Women.*

Reach Higher

Who are pioneering people in your life? What other characteristics do they have that help them be trailblazers and pave the way for others?

Shine Brighter

Besides Jehosheba, there are other examples in the Bible of pioneers (e.g., Jesus, Ruth, David, Lydia). Pick one and write about what makes them pioneering.

pioneer

pi·o·neer /ˌpīə'nir/
noun

1. a person who is one of the first to settle an area
2. a person who begins or develops something new and prepares the way for others to follow
3. _____ (fill in your name!)

DEPENDABLE
Joanna

As a loyal disciple of Christ, Joanna was dependable. She traveled with Christ, used her resources to help take care of Him, supported Him at the cross, and even cared for His body after His death.

Luke 8:1–3; Luke 24:1–12, 22–24

Dear divine daughter, how can you be more dependable in your service to God?

See page 22 in *Dear Divine Daughter: Inspiring Stories of Bible Women.*

Reach Higher

What are things a dependable friend does? What are things they do not do? Who is a friend you can depend on and why?

Shine Brighter

Dependable comes from the Latin words *de* ("down" or "from"), *pendere* ("to hang"), and *abilis* ("capable of"). Essentially, a dependable person is someone you can hang on or lean on. List ways you can lean on Christ and ways He can lean on you.

lean on
HIM

CREATIVE
Jochebed

Jochebed was creative when she came up with a clever way to save her baby boy from death. She made a waterproof basket using reeds from the riverbank and floated him down the river to safety.

Exodus 2:1–10; Exodus 6:20; Numbers 26:59; Hebrews 11:23–27

Dear divine daughter, how can you use your creativity to do good things?

See page 25 in *Dear Divine Daughter: Inspiring Stories of Bible Women.*

Reach Higher

The very first verse of the entire Bible says, "In the beginning God created the heavens and the earth." Think about all of the wonderful creations God has made. Closely inspect different flowers, leaves, fruit, or other things in nature. Why do you think God created such diversity? Which creations are most beautiful to you?

Shine Brighter

Create a new recipe using food you already have in your home.
Try it out and tweak your recipe if needed.

Being creative involves using your imagination or your own original ideas. If you could invent anything, what would it be? Write about it or draw a picture of it.

VIRTUOUS
The Little Maid

The Little Maid was virtuous when she told Naaman about the prophet, even though Naaman was her enemy. Her virtuous act was the reason Naaman found healing from his painful skin disease.

2 Kings 5:1–14

Dear divine daughter, how can you be virtuous and show high moral standards?

See page 26 in *Dear Divine Daughter: Inspiring Stories of Bible Women.*

Reach Higher

Choosing the right is always good, even when it is hard to do. Is there something you are doing that you know is wrong? How can you right your wrong, and how will doing so bless your life?

Shine Brighter

Who is someone you struggle to get along with or like? Write down five things you like about them. Sincerely compliment them by sharing one of the things you wrote. What was their reaction, and how did the conversation make you feel?

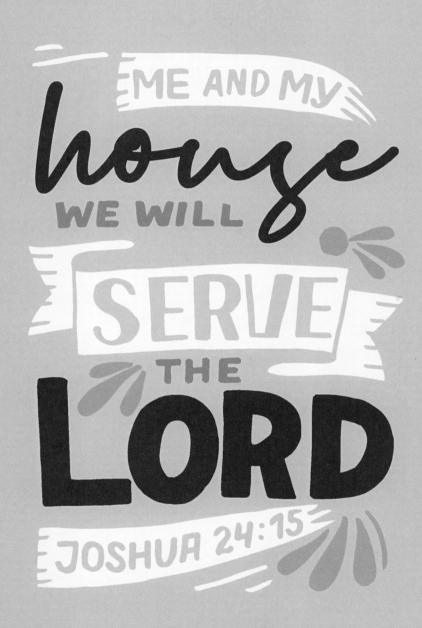

INFLUENTIAL
Lydia

Lydia was influential when she made the decision to be baptized. Her entire household followed her good example and chose to be baptized too.

Acts 16:12–15, 40

Dear divine daughter, how can you be a righteous influence on others?

See page 29 in *Dear Divine Daughter: Inspiring Stories of Bible Women.*

Reach Higher

Is there someone who looks up to you? (Age does not matter.) What is something you can do to set a good example for them? How could that be important in their life?

Shine Brighter

Write a thank you letter to someone who has been influential in your life. How has this person influenced your life for the better?

BE A
light
SHINE
bright

CARING
Martha

Martha was caring when she welcomed Jesus into her home and made sure He was well taken care of. She also served Jesus during His last week on earth.

Luke 10:38–42; John 11:1–44; John 12:1–2

Dear divine daughter, how can you be more caring?

See page 30 in *Dear Divine Daughter: Inspiring Stories of Bible Women.*

Reach Higher

What does "thou shalt love thy neighbor as thyself" (Matthew 22:39) mean to you?

Shine Brighter

Take a treat or surprise to someone you know who needs some cheering up. Tell them that you care. (If you want to, you can use our mom's cookie recipe on the next page!) How did caring for "thy neighbor" make you feel?

65

GRANDMA JAN'S
chocolate chip cookie
RECIPE

INGREDIENTS

- 1/2 cup softened butter
- 3/4 cup sugar
- 3/4 cup brown sugar
- 1 teaspoon vanilla
- 2 eggs
- 2 1/4 cup flour
- 1/2 teaspoon salt
- 1 cup milk chocolate chips

DIRECTIONS

1. Preheat the oven to 350°F. Mix the sugar, brown sugar, and butter with a hand mixer on medium speed.
2. Mix in the eggs and vanilla.
3. Add the baking soda and salt. Then slowly pour in the flour and mix while adding.
4. Finally mix in the chocolate chips.
5. Scoop little cookie dough balls onto a baking sheet and bake for 8–10 minutes until the edges turn golden brown but the middles still look soft and gooey.
6. Using a spatula, move the cookies from the pan to a cooling rack.

DEVOTED
Mary Magdalene

As one of Jesus's most devoted friends, Mary Magdalene supported Jesus as He died on the cross, visited the tomb He was buried in, and was the first person to see Him resurrected.

Luke 8:1–3; Luke 24:1–12; Matthew 27:55–61; Matthew 28:1–10;
Mark 15:39–47; Mark 16:1–11; John 20:1–18

Dear divine daughter, how can you be a more devoted disciple?

See page 33 in *Dear Divine Daughter: Inspiring Stories of Bible Women.*

Reach Higher

What does it mean to be a loyal friend? In what way do you consider Christ your friend?

Shine Brighter

We close our prayers by saying, "In the name of Jesus Christ, amen." The next time you pray, slow down at the end, think about all that Jesus has done for you, and say His name with reverence and respect. Write your thoughts about the experience.

Draw or write about an activity, person, or cause that you are devoted to. (Something that you put a lot of time or energy toward.)

RECEPTIVE
Mary, Mother of Jesus

Mary the mother of Jesus was receptive when she was willing to be God's servant and do anything God asked of her. She often pondered on Jesus's words and kept them in her heart.

Luke 1:26–38; Luke 2; John 19:25–27

Dear divine daughter, how can you be more receptive to God, the Holy Ghost, and others?

See page 34 in *Dear Divine Daughter: Inspiring Stories of Bible Women.*

Reach Higher

Ask a family member or friend the question, "What is one thing I can do to improve?" During the conversation, try not to argue or disagree but to see things from their perspective. Ask questions and let them do most of the talking. Now, write down what they said. Do you agree with them? (You can still be receptive and disagree! Being receptive means being willing to consider or accept a suggestion or idea.) Write down any other thoughts you have.

Shine Brighter

Say a prayer with the purpose of listening to promptings. Try to have a conversation with God, and pay attention to the whispering of the Spirit. Write about your feelings, thoughts, and experience.

HUMBLE
Mary of Bethany

Mary of Bethany was humble and was often found at Jesus's feet. For example, she sat learning at His feet, fell at His feet weeping, and reverently anointed His feet with oil.

Luke 10:38–42; John 11:1–45; John 12:1–8

Dear divine daughter, how can you be more humble?

See page 37 in *Dear Divine Daughter: Inspiring Stories of Bible Women.*

Reach Higher

Humility means being teachable; it does not mean acting small or degrading yourself. How can you be humble without making yourself smaller or downplaying your amazing strengths?

Shine Brighter

It is humbling to know that all of our blessings come from God. Think of things you are grateful for, and list as many as you can in the space provided.

Never underestimate the power
you have when you humbly fall
to your knees in prayer.

SELFLESS
Michal

Michal was selflessly willing to put her own life at risk in order to save her husband. When his life was in danger, she came up with an escape plan to help him flee.

1 Samuel 18:20–30; 1 Samuel 19:8–18

Dear divine daughter, how can you be more selfless and help others in their time of need?

See page 38 in *Dear Divine Daughter: Inspiring Stories of Bible Women*

Reach Higher

What might you be asked to give up in the service of others? How does it feel to put the needs of others before your own needs and desires? What opportunities to serve others do you encounter on a daily basis?

Shine Brighter

Give something you love or value to someone else. What was the item, and why is it important to you? Who did you pick to give it to, and why did you choose them? How did your selfless gesture make both of you feel?

Draw how you enjoy selflessly serving others.

CONFIDENT
Miriam

Though a lowly slave, young Miriam boldly approached the princess with a question, helping to reunite her family. Later, Miriam became a confident leader and prophetess.

Numbers 26:59; Exodus 2:1–10; Exodus 15:20–21; Micah 6:4

Dear divine daughter, how can you be more confident?

See page 41 in *Dear Divine Daughter: Inspiring Stories of Bible Women.*

Reach Higher

Pretend you have all the confidence in the world. How would you act differently in your relationships, at school, and at home? How would the spiritual, intellectual, and physical areas of your life change? What is stopping you from being more confident?

Shine Brighter

Look at your eyes in the mirror for a minute, and be proud of who you are. Then, stand up tall, pull your shoulders back, put your hands on your hips, lift your chin, and smile brightly. Confidently and out loud tell yourself that you are a daughter of God. How do you feel about that person in the mirror? What do you think God sees when He looks at you?

Write a list of things you love about yourself.

86

LONG-SUFFERING
Naomi

Naomi was heartbroken when her husband and two sons died, but she was not angry with God. She endured her many trials with faith and patience.

Ruth 1; Ruth 2:1–3, 18–23; Ruth 3:1–6, 16–18; Ruth 4:3–17

Dear divine daughter, how can you be more long-suffering and endure hard things?

87 See page 42 in *Dear Divine Daughter: Inspiring Stories of Bible Women*.

Reach Higher

If we look for it, there is a bright side of every situation. Write down hard things that you are experiencing or have experienced. Then, write how each trial has been a blessing to you and/or others.

Shine Brighter

Many people have difficult struggles. Think of someone you know who has had an ongoing trial. Interview them about their experience, and ask how they have been able to be long-suffering through it all. Write about your conversation.

GENEROUS
The Poor Widow

The Poor Widow was generous when she gave two small coins to God. Others gave more money but could have given much more. The Poor Widow gave all she had.

Mark 12:41–44; Luke 21:1–4

Dear divine daughter, how can you be more generous to God and others?

See page 45 in *Dear Divine Daughter: Inspiring Stories of Bible Women.*

Reach Higher

What do you think the scripture, "It is more blessed to give than to receive" (Acts 20:35) means? Do you think that statement is true? Why or why not?

Shine Brighter

Do a generous act. Here are some ideas: donate groceries to your local food bank, give a generous church offering, spend time playing with a younger sibling, or give up some free time to help your mom or dad. What did you decide to do? Write about your experience.

God
will generously
provide
all you
need

2 Cor 9.8

GOD-FEARING
Puah and Shiphrah

Midwives Puah and Shiphrah disobeyed the wicked king, risking their own lives to save baby boys from drowning. Because they cared more about what God thought than the king, Puah and Shiphrah were blessed.

Exodus 1:7–21

Dear divine daughter, how can you be more God-fearing?

See page 46 in *Dear Divine Daughter: Inspiring Stories of Bible Women.*

Reach Higher

The word "God-fearing" happens to have the word "fear" in it. Why do we actually not need to fear when we choose to obey God and care about what He thinks?

Shine Brighter

Sometimes people do things they should not just because they are following the crowd and care what others think of them. What are some things you hear or see at school (or other places you spend time) that you are not going to do?

WITH GOD
WEAK THINGS
BECOME

strong

ACTION-ORIENTED
Rahab

When two righteous men were in trouble, Rahab quickly came up with a plan. Helping them hide and escape from the king, she saved them and her entire household from destruction.

Joshua 2; Joshua 6:1–5, 17, 22–25; Hebrews 11:31

Dear divine daughter, how can you be more action-oriented and act on your faith?

See page 49 in Dear Divine Daughter: Inspiring Stories of Bible Women.

Reach Higher

In the parable of the talents (Matthew 25:14-30), the master got angry at his lazy servant. Jesus used this parable to teach that we reap what we sow. (In other words, what we plant is what we harvest.) What are synonyms for the word "lazy"? Why is taking action righteous and a necessary part of God's plan for us?

Shine Brighter

What big goal do you want to accomplish? Make a list of things you can do this year, this month, and this week to help make that happen. Follow through and do it!

my dream board

Write or draw a goal you have in each box.

education & career

mental health

money & finance

spirituality

A *dream*
is just a dream
until you *do*
something
about it.

service & giving

family & friends

physical health

fun & creativity

INSPIRED
Rebekah

On multiple occasions, Rebekah received inspiration from God and acted on those promptings. Because of this, she was an instrument in God's hands to bring about His work.

Genesis 24; Genesis 25:20–34; Genesis 27:5–29

Dear divine daughter, how can you become more inspired and receive revelation from God?

See page 50 in *Dear Divine Daughter: Inspiring Stories of Bible Women.*

Reach Higher

Revelation does not only come as a grand vision, a holy visitation, or a thunder-and-lightning experience. Almost always it is much more simple and subtle than that. A warmness in your heart, a righteous thought in your head, and a peaceful feeling are examples of how God could be communicating to you. How can you make yourself more able to pay attention to these small, quiet revelations?

Shine Brighter

Say a prayer and ask God who you can bless today. If someone pops into your head, think about what you can do to serve them or show your love for them. Follow through right away and write about your experience.

Search

ponder

Pray

REPENTANT
The Repentant Woman

Deeply sorry for her sins, the Repentant Woman bowed before Jesus, kissing and washing His feet. Jesus complimented her faith, forgave her, and told her to go in peace.

Luke 7:36–50

Dear divine daughter, how can you be more repentant?

See page 53 in *Dear Divine Daughter: Inspiring Stories of Bible Women.*

Reach Higher

Why is repenting an important thing to do? How do you think God feels when someone repents?

Shine Brighter

You do not have access to Jesus's feet right now, but you do have access to God through prayer. Say a prayer of repentance and see if you feel God's forgiveness and His approval of you. Make it a goal to repent every night this week. Write about your experience.

GOD
LOVES
you NO
MATTER
WHAT!
seriously.

PERSISTENT
Rhoda

Rhoda heard the voice of the prophet and insisted it was him even when others thought she was crazy. To everyone's astonishment, what Rhonda had persistently told them was true.

Acts 12:1–17

Dear divine daughter, how can you be more persistent despite opposition?

See page 54 in *Dear Divine Daughter: Inspiring Stories of Bible Women.*

Reach Higher

How can knowing that you are a daughter of God help you be more persistent in choosing the right? How can this deep sense of your divine identity help you when you face challenges or obstacles?

Shine Brighter

Building good habits takes time and persistence. What good habit would you like to build? After fourteen days of consistently developing your new habit, write about your experience.

I know I can _____.

I know I can. I know I can.

I know I can.

I know I can.

I know I can.

I know I can.

I know I can.

I know I can.

I know I can.

I know I can.

I know I can.

I know I can.

I know I can.

I know I can.

I know I can.

I know I can.

I know I can.

I know I can.

I know I can.

I knew I could.

LOYAL
Ruth

Ruth showed constant love and support for her mother-in-law, Naomi. Ruth sacrificed a lot to stick by Naomi's side, but her loyalty never wavered.

Ruth 1–4

Dear divine daughter, how can you be more loyal?

See page 57 in *Dear Divine Daughter: Inspiring Stories of Bible Women.*

Reach Higher

Romans 8:39 says, "Nor height, nor depth, nor any other creature, shall be able to separate us from the love of God, which is in Christ Jesus our Lord." How does this scripture demonstrate God's loyalty to you?

Shine Brighter

Draw or write about what your typical day looks like from when you wake up to when you go to bed. Are you being loyal to God and giving enough of yourself to Him? How can you make Him the central focus of your day?

His **LOVE** endures FOREVER PS. 100.5

MISSIONARY-MINDED

The Samaritan Woman at the Well

The Samaritan Woman at the Well dropped what she was doing and ran to invite everyone to come see Jesus. Many people were motivated by her passionate testimony and came to see for themselves.

John 4:6-30, 39–42

Dear divine daughter, how can you be a better missionary and invite others to come unto Jesus?

See page 58 in *Dear Divine Daughter: Inspiring Stories of Bible Women.*

Reach Higher

With missionary work, you never know how the other person will react or who will accept your invitation. If you do not have control over how your message is received, what do you have control over? Explain your answer.

Shine Brighter

Share your testimony with someone. First, practice what you want to say by writing down your testimony.

Write about or draw what makes you hesitant to do missionary work. Then, cross out each obstacle and commit to not letting them get in your way!

PROBLEM-SOLVING
The Shunammite Woman

The Shunammite Woman actively looked for ways to fix bad situations in her life. She also used her problem-solving skills to help others, including her family and the prophet.

2 Kings 4:8–37; 2 Kings 8:1–6

Dear divine daughter, how can you take initiative and find solutions to problems in your life?

See page 61 in *Dear Divine Daughter: Inspiring Stories of Bible Women.*

Reach Higher

Think about a time when you had to solve a problem. What did you do? What was the result? Looking back, what might you have done differently? How does it feel to be a problem-solver?

Shine Brighter

Try these steps to solve a problem in your life:

1. Identify the problem.

2. Brainstorm three to five things you can do to solve your problem.

3. Write down the pros and cons of each idea.

4. Put a star next to the best idea, and give it a try!

5. Evaluate your solution. How did it go? Did it fix your problem, or do you need to try another solution?

I can
DO
ALL THINGS
THROUGH
Christ
WHO
STRENGTHENS ME
PHILIPPIANS 4:13

CHARITABLE
Tabitha

Tabitha was often found giving to the poor and lonely. She was known for her good works and deeds, including sewing coats and clothes for widows.

Acts 9:32, 36–42

Dear divine daughter, how can you be more charitable and help those in need?

See page 62 in *Dear Divine Daughter: Inspiring Stories of Bible Women.*

Reach Higher

Who in your life is often found giving to those in need? How do they demonstrate the description of charity found in the following scripture: "Charity suffereth long, and is kind; charity envieth not; charity . . . is not puffed up" (1 Corinthians 13:4)?

Shine Brighter

One thing we can be charitable with is our time. Visit or call someone who you think might be lonely, and spend your time getting to know them better. What did you learn about them? How did your visit impact them?

"[If] ye have done it unto one of the *least* of these . . . ye have done it unto *me.*"

FAITHFUL
The Widow of Zarephath

The Widow of Zarephath was about to starve, but she gave the prophet her last bit of food first and had faith that God would provide. Her act of faith brought a miraculous blessing—her flour and oil did not run out.

1 Kings 17:8–16

Dear divine daughter, how can you be more faithful?

Reach Higher

What is a trial in your life or a loved one's life? Sometimes our desire to have trials removed does not line up with God's will. What might God be wanting you to learn or do with that trial?

Shine Brighter

Faith is all about action! We show our faith by choosing to believe and trust God and by obeying Him and following His commandments. Faith does not just happen to you; you have to exercise it. To exercise your faith today, choose one of the following:

1. Say a prayer and talk to God like He is in the room with you, and write about your experience.

2. Study your scriptures and write down what you learn.

3. Come up with your own faith-building idea and write about it.

Growing your faith can be like growing a plant from a seed.
Draw the step-by-step process of growing a flower.

Step 1: Gather the needed supplies.

Step 2: Plant the seed in soil.

Step 3: Place your pot in the sunshine.

Step 4: Water and fertilize the soil.

Step 5: Patiently wait for the plant to grow.

Step 6: Enjoy the blossoms!

Write about how this process relates to growing your faith.

INDEPENDENT
The Wife of Pontius Pilate

The crowd in Judea wanted to crucify Jesus, but the Wife of Pontius Pilate knew He was innocent. She defended Jesus and would not be swayed to think otherwise despite peer pressure from an angry crowd.

Matthew 27:1-2, 11-26

Dear divine daughter, how can you be more independent and stand for what is right instead of following the crowd?

See page 66 in *Dear Divine Daughter: Inspiring Stories of Bible Women.*

Reach Higher

Who is someone you know who stands out from the crowd in a good way? What things or experiences have made them stand out? What are some qualities you admire about them?

Shine Brighter

Write down a list of things that your parents do for you (maybe doing your laundry, making you breakfast, helping with schoolwork, waking you up in the morning, cleaning your room, putting your dish in the dishwasher, reminding you to pray, etc.). Becoming more independent can mean taking on more responsibility and becoming more self-sufficient. Circle one thing from your list that you want to do independently. If needed, have your parents teach you how to do it, and then try it out on your own. Write about your experience.

Choose
YOU
this day whom ye will serve.

—Joshua 24:15

DETERMINED

The Woman With an Issue of Blood

The Woman With an Issue of Blood suffered for twelve years despite visiting many doctors. Determined to be whole again, she reached out to Jesus and was finally healed.

Leviticus 15:25-30; Mark 5:24-34; Luke 8:43-48

Dear divine daughter, how can you be more determined when you face challenges?

See page 69 in *Dear Divine Daughter: Inspiring Stories of Bible Women.*

Reach Higher

We can strengthen our determination by figuring out our "why." Why are you working through this journal, and why is becoming more Christlike important to you?

Shine Brighter

Affirmations are positive statements that help encourage you, help you overcome negative thoughts, and help you stay determined. (For example: I am a beloved daughter of God! I will choose to follow Christ! I am strong even when life is hard!) Write some affirmation declarations for yourself. Practice saying them with determination in front of a mirror.

DIVINE & HERE TO SHINE

(Your Name Here)

Now that you have worked through this journal, we hope you feel more Christlike and more like inspiring Bible women. You can use your natural strengths and the characteristics you have been developing to do good and to be a light!

Dear divine daughter, look how far you have come! What was the most powerful thing you learned or experienced while using this journal?

See page 70 in *Dear Divine Daughter: Inspiring Stories of Bible Women.*

Reach Higher

What are some of your biggest strengths, and how do you use them to bless others? What is something you know you still want to work on, and how are you going to keep developing that characteristic?

Shine Brighter

Write a letter to your future self.

Paste in or draw a picture of yourself
being divine and here to shine!